PRISON PAINTINGS

MICHAEL QUANNE

With an introduction by
John Berger

JOHN MURRAY

I would like to thank John Berger and Lawrence
Peter whose support has been vital for my book;
also Colm Kerrigan who made many helpful
corrections to the captions.

© Michael Quanne 1985
Introduction © John Berger 1985

First published 1985
by John Murray (Publishers) Ltd
50 Albemarle Street, London W1X 4BD

Origination by Anglia Reproductions
Printed and bound in Great Britain
by Hazell Watson & Viney Ltd,
Member of the BPCC Group,
Aylesbury, Bucks.

British Library CIP Data

Quanne, Michael
 Prison paintings.
 1. Quanne, Michael
 I. Title
 759.2 ND497.Q8

 ISBN 0-7195-4228-6

INTRODUCTION
by John Berger

The Cherished and the Excluded

He was born forty-three years ago in Surrey, south of the river, but when he was one year old the family moved to Bethnal Green in the East End. It was in those post-war streets, as typical of London as was Dickens, that he learnt to dream, to run, to watch: the same streets and tenements that thirty years later he was going to paint. He failed the eleven-plus. 'The educational system is grounded in words and at home words were in short supply. I was verbally inarticulate.'

> You're like book ends, the pair of you, *she'd say*,
> Hog that grate, say nothing, sit, sleep, stare...
>
> TONY HARRISON

'At school I liked drawing maps and colouring in the countries. The only thing I liked. I didn't know the capitals, it was the outlines that got me.' The painter was already there in embryo. Also the indefatigable questioner – but at that stage the questions were not formulated, they were simply impulses to get around what *was*, to leave this side in order to see the other, the obverse, to *be* (the word *play* cannot apply) truant.

Last month in the Paris Metro he asked me: 'You, do you believe in Free Will?' I mumbled something equivocal. 'I read a book by Sartre,' he said, 'and whenever he spoke of free choice I got out a magnifying glass to make sure it was really there, and I never found it.'

At the age of sixteen he was arrested for the first time on a charge of attempted larceny. Since then the longest period he has been out of prison is three years. Most of his adult life he has been inside. *Inside* might be another title for this book. Only in one painting (the one at the seaside) are there no walls, no windows, no railings. All the others concern incarceration of one kind or another. How many faces peer out of windows! I have counted thirty.

'Remember in *War and Peace*,' he asked me, 'when Pierre is arrested and is about to be executed? He's spared at the last moment and then he watches the soldiers burying the ones they've already killed.'

> Pale frightened figures busied themselves around the body of the last one shot. An old soldier with a handsome moustache untied the rope and, as he did so, his jaw was trembling. The corpse fell to the ground. Others made haste to drag the body behind the firing stake and to dump it in a trench. It was clear they knew they were assassins and they wanted to cover up their crime as quickly as possible.

'That passage,' he said, 'came to my mind years ago, when a Judge gave me seven years. He hurried through the sentence and he didn't want to look at me. He knew he was doing wrong.'

Authority dreams with its eyes shut of the efficacy of its punishments (no authority dreams of justice), just like the woman in a blue dress with her eyelids closed, the woman who once punished kids by making them dance in front of the class, and who still appears in his nightmares.

To enter the world as lived by Michael Quanne, it is necessary to abandon the idea that justice exists on this earth, the idea that people mostly deserve what they get, that money is usually a reward for effort and skill, that everyone has a more or less equal chance to make up their minds and come to decisions, that the good and brave are finally honoured, that the 'social good' is something to be debated about so that the best argument may triumph, to abandon the expansive space of such complacency where all horizons are moral, and, by contrast, to enter a crowded corner of a sprawling edifice, where nine out of ten doors are locked, where there are no perspectives, no horizons, but only deteriorations (downhill), where nearly everything which happens in your corner is chancy and arbitrary, where there are no appeals because there have never been addresses to which to deliver them, nor incumbents to read them, and where the only thing that is straight is what you tell yourself. It is to leave the privileged and to join the excluded.

> Through tatter'd clothes small vices do appear;
> Robes and furr'd gowns hide all. Plate sin with gold,
> And the strong lance of justice hurtless breaks;
> Arm it in rags, a pigmy's straw does pierce it.

<div align="right">

King Lear Act iv, Scene 6

</div>

The word *Primitive* when applied to a painter like Michael Quanne is doubly confusing. Quanne is a highly self-conscious and skilful artist. (Talking with him about art reminds me of conversations with L.S. Lowry who was about as primitive as a Zen Buddhist monk.) Furthermore, there is a confusion lurking in the label itself and this we need to understand if we are to come to terms with Quanne's achievement.

Any professional painter learns a given language of painting and this language – when seen from far away – is always limited because it has been developed to express and satisfy certain experiences and not others. Every art form is intimately related to a type of life experience. The difference between chamber-music and jazz is not one of quality, finesse or virtuosity but of two ways of life, which the people involved did not choose but were born into. The professional skill learnt by an apprentice in Gainsborough's studio was ideal for painting feathers and satin and useless for painting a *Pietà*.

Every style in art cherishes certain experiences and excludes others. When somebody tries to introduce into painting a life-experience which the current style or traditional styles exclude, he is always dubbed by the professionals *crude, clumsy, grotesque, naive, primitive*. (It happened to, amongst others, Courbet, Van

Gogh, Kathe Kollwitz, and earlier to Rembrandt.)

It would be wrong to explain this phenomenon by the bad faith of the professionals for, in a sense, the epithets are correct. The intruding experience cannot share the culture of the cherished ones. It has its own culture, a culture of exclusion. Its very nature demands, in relation to prevailing taste, an apparently disjointed, distorted or clumsy expression. How can it preserve its memories of exclusion and at the same time be suave?

This said, Michael Quanne's paintings are very remarkable because of the richness and subtleties of the experience they relate. Each figure, however minor, is a portrait; there are no stereotypes. (Undoubtedly Quanne is a story-teller because he has that kind of observation: when he looks at a face, he senses a destiny.) Every painted gesture derives from active experience – look at the figures climbing the wall in *Mass Escape*, or the boy lifting the pails in *Breakfast Time*, or the couple walking towards us in *Umbrellas*. I say 'couple' because, although they are children, they are already elderly.

This ambiguity in his art about age (he turns those who are adults in life into children in his paintings) is rooted, I believe, in his experience and is perhaps related to three insights: that kids who live on the street mature early, that prisoners are treated like punished children, and that, among those whom the law finds guilty, many might claim a never-to-be-formulated innocence. About this innocence there is nothing soulful or poetic; it is simply the *affair and its circumstances seen from the other side*, from the side where little is ever formulated, yet where the appetite for love – and if not love, respect – is undiminished.

Lastly, I would like to point out a dimension in his art which does not derive from a specific milieu but which is universal: the felt presence of what is not visible. Each of his paintings is like something closely studied through a window – an outside seen from inside, or an interior seen from outside. One can, of course, approach all paintings in this way. But in his, you are made conscious that the 'window' is set into a wall which hides. In what we see there is a haunting sense of what lies beyond the frame. The bottom of the hill to which the roller-skaters are heading. The worst – that which Quanne says he'd rather not paint – the prison gates, the dock, the Scrubs. The mysterious place from where the animals have come. The sky in which the kite will fly. The immanence behind (or within?) each brick. The garden outside for which the trikes in the room were made…This is a book made up of images of incarceration – and dreams of freedom.

John Berger
January 1985

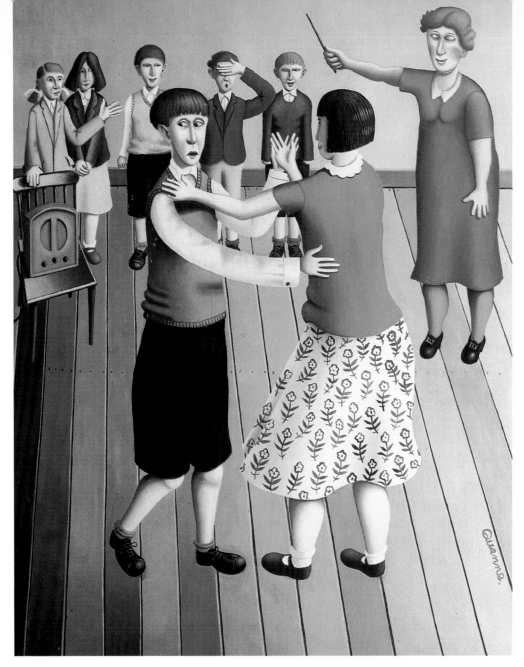

Punishment

I knew a lady once who had a great imagination when it came to dishing out punishment. She was in charge of us at the home in Torquay where I was evacuated during the War and could have made the world's worst judge look like an amateur. One of this lady's tricks was to make any boy who misbehaved dance with one of the girls in front of everybody. Funnily enough I got over my last prison sentence ten minutes after walking through the gates, but the lady at Torquay crops up in my nightmares to this day.

Skating Downhill

If the look on the face of the girl in the pink dress is anything to go by, the boy in front is bang in trouble.

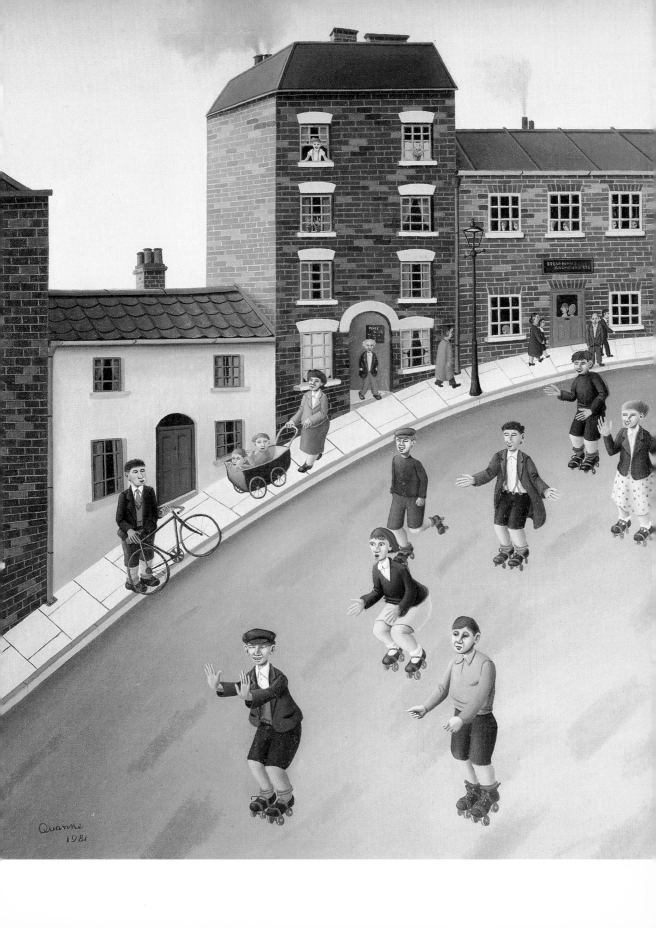

Swing Park

What was it about swing parks that made me head in the opposite direction? In this painting I'm the one carrying the kite. My love of kite flying began at about the same time as the onset of my aversion to swing parks, so I've included both here.

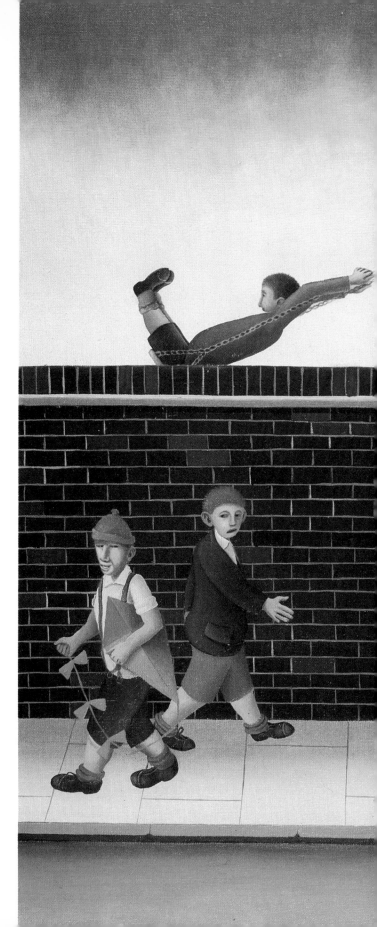

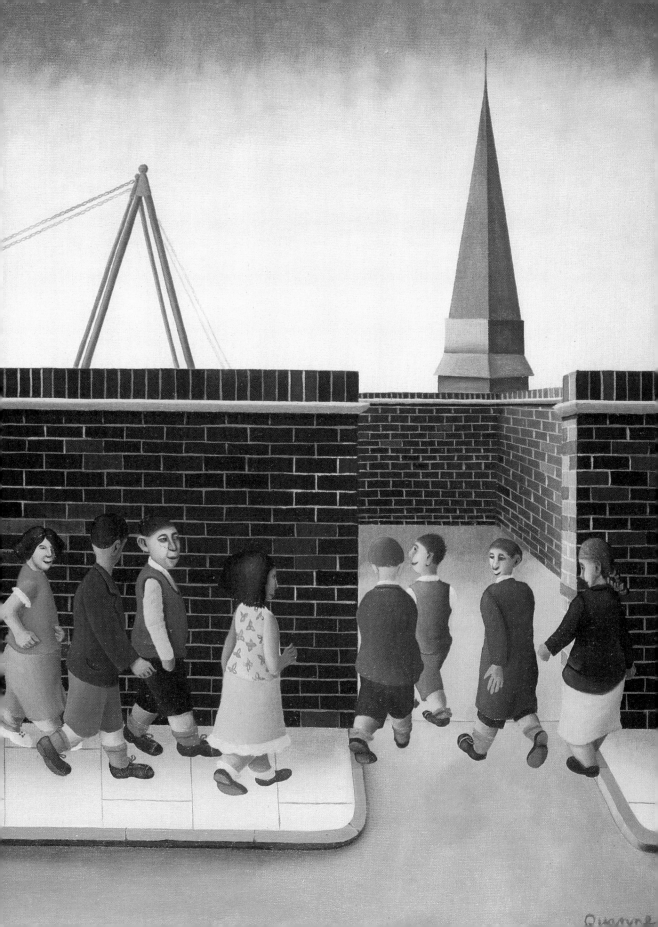

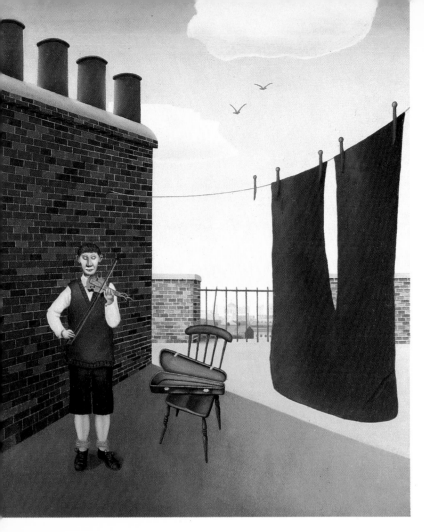

Prison Dream

Normally I don't have very weird dreams. But the one I had just after getting my last prison sentence takes some beating. Believe it or not I dreamt I was a donkey. Or at least I could hear a voice in the dream telling me I was a donkey even if I couldn't actually see myself being one. And to make matters worse I knew in the dream that I was trying to race this big rocking horse in a picture on a street hoarding. I had a little kid on my back as well, crying his eyes out because he couldn't get going. As you can see in the painting, the rocking horse was carrying a clown who must have thought he was winning the race because he kept laughing and shouting non-stop like a lunatic. It was great waking up from that one, a real nightmare.

Child Violinist on Tenement Roof

In 1948 we lived in this Bethnal Green tenement called Co-op Buildings that had a roof you could go up onto if you wanted to have a look at St Paul's in the distance or launch paper aeroplanes down into the street. Later on, when I was fourteen, we were moved to the council flats round the corner and the old building was boarded up. It stayed that way until it was demolished in 1980.

Imagine anyone in their right mind getting nostalgic over a bug-ridden tenement called Co-op Buildings. I'd actually pass it sometimes on the opposite side of the road so that I could look up at our third-floor windows. I was probably trying to see myself up there before the rot set in. In a way it's pathetic. I must have been looking for clues or something. When they finally pulled the building down I was in prison so I didn't see it happen. I can't really play the violin but I've painted myself playing a suitably sentimental tune on one.

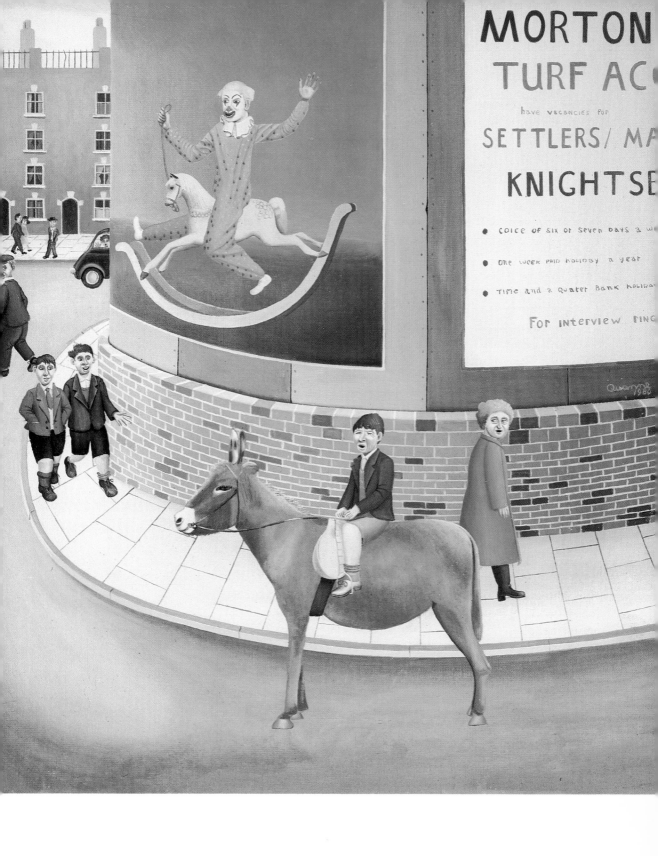

Tower Green

The first time I visited the Tower of London I can remember looking down into one of the dungeons and wondering what it would be like if they kept me there for years. I can have a good laugh at the irony of it now, but then I was just a local ten-year-old and still with a clean record. When I decided after being released from my last sentence to do this painting I went back to the Tower for inspiration, to hopefully evoke the memory of my first visit. I thought it best not to include in this painting that White Tower image which you see in all the post cards. Instead I've tried to paint a view of Tower Green with its overlooking Tudor houses. As a matter of interest, from one of those windows, Lady Jane Grey, imprisoned there, watched one morning as her husband was taken to his execution. Later she went the same way.

Young Crook on Horseback

I acquired a taste for classical music in prison and then began by borrowing all the well-known stuff from the local library. Then composers I'd never heard of just to find out what they were like. Finally I began to try out albums with covers that you couldn't even tell from looking at it if there was music inside. This painting comes from one of those. The music I heard when I played Stockhausen's *Trans* for the first time produced such a clear picture in my head that I could have painted it in detail a year later. The sound itself I took to be of a horse clopping on cobblestones. But it wasn't, as far as I could tell, an ordinary horse and the clopping wasn't ordinary clopping. Hardly anyone has so far liked the painting. In fact I wasn't going to include it in this book. But when I looked at it again I knew that it was one of the best things I'd ever done.

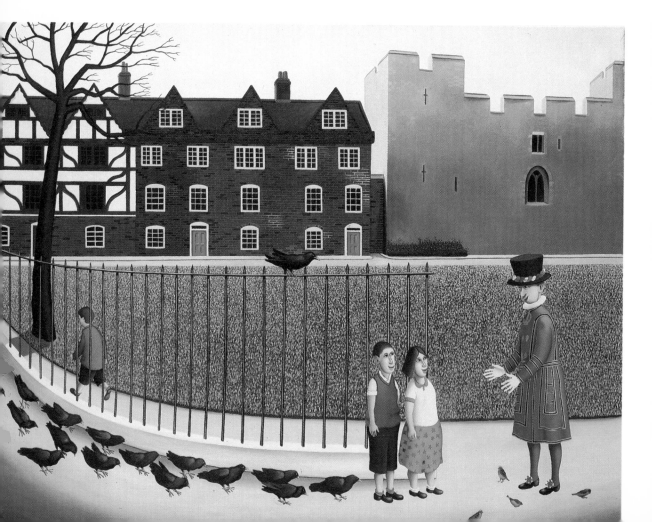

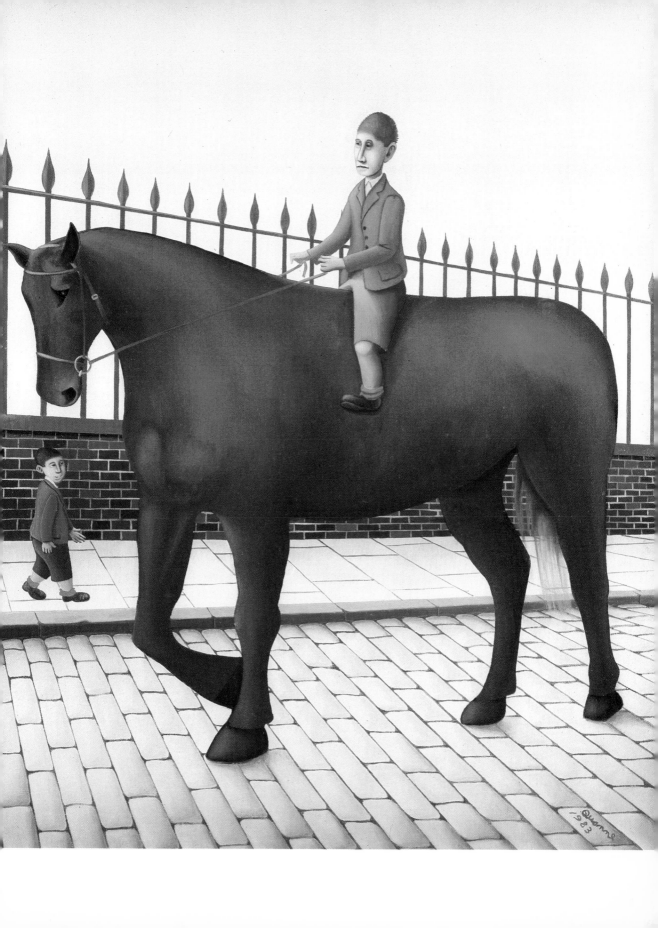

Street Party

This must be my most cynical painting. It's supposed to represent one of the typical East End street parties for kids which were always being held in the Forties and early Fifties. As far as I can remember everyone always had a good time at them. Everyone except me, that is. The truth is I'd sooner have gone to approved school than to a street party. I couldn't tell you why though. I just didn't like them. No wonder I ended up in the jug, being anti-social even at that age. I'm one of the kids with the masks. At least my mask looks as if it's having a good time.

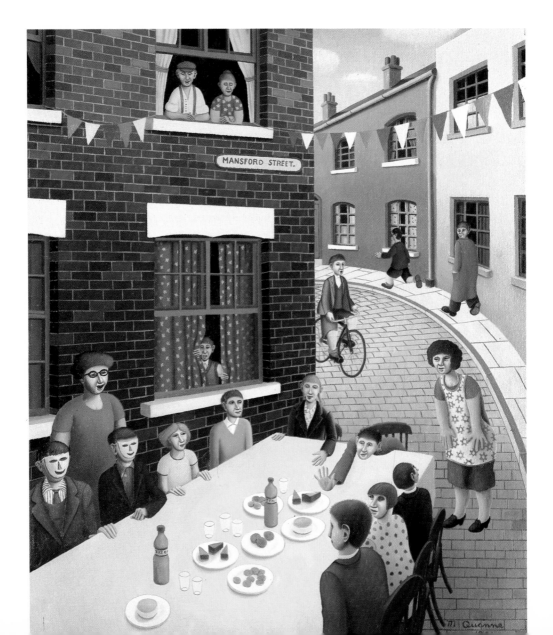

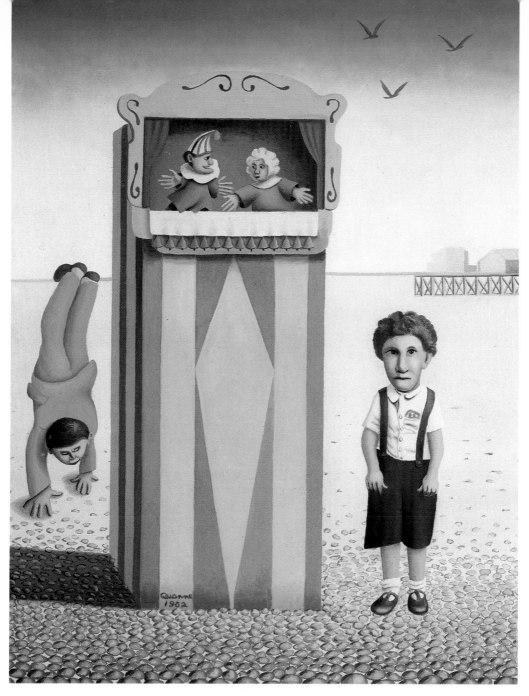

Young Offender at the Seaside

This portrait of myself aged four was inspired by an old photograph that my Mother has kept. It shows me dressed up like little Lord Fauntleroy and looking as if butter wouldn't melt in my mouth which may have been true at the time. The seaside background is my own idea. As a parody on the black and white view some people have of criminals I've given myself a little thug's face. The young man doing hand-stands is me when I was trying to get this book published.

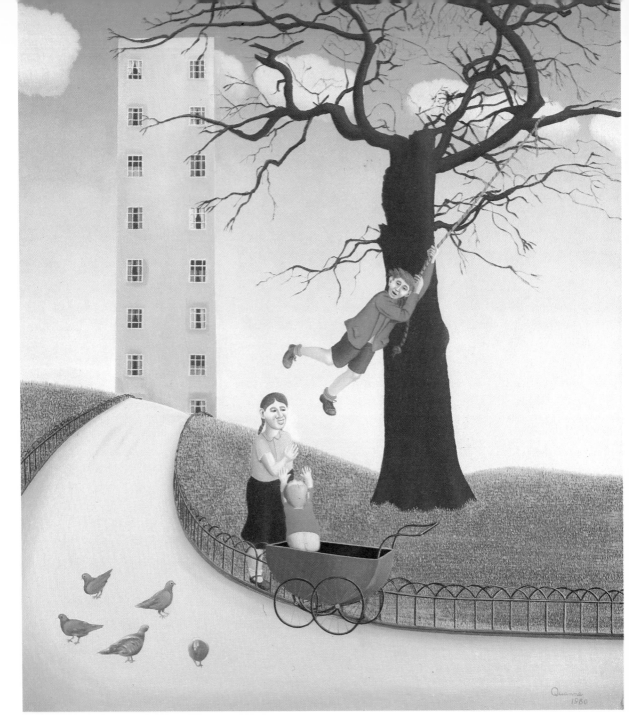

Kids in Park

The one thing I couldn't stand when I was a kid were those iron playground swings they had in parks – backwards and forwards, stop and start. Just the right kind of training for future judges. As far as I was concerned the best swings were always the ones you made yourself by tying ropes to old trees.

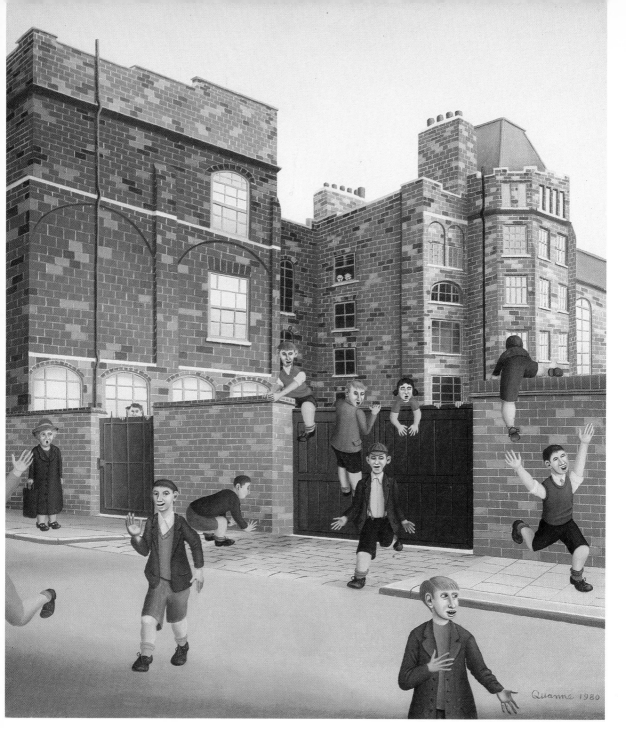

Mass Escape 1948

Our school gates were always kept locked, probably just so that unwanted visitors couldn't get in. But one day a few of us decided we were suffering from claustrophobia and made a bid for freedom during playtime. The teachers rounded us all up in about ten minutes though and then gave us the stick one after the other. So much for freedom.

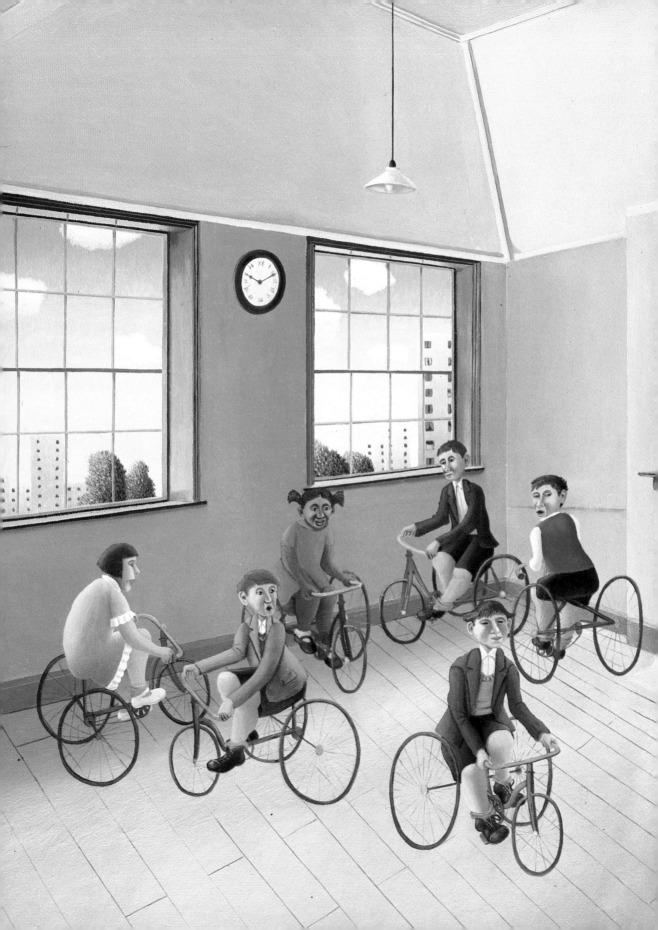

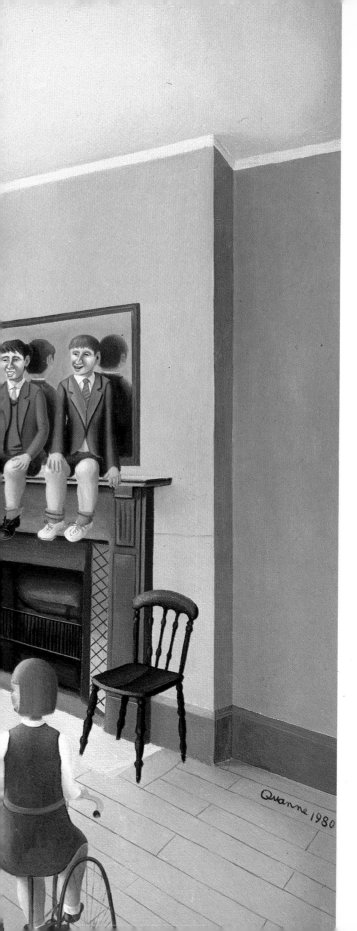

Trike Room

At Torquay they had this room full of
trikes we were sometimes allowed to
use. Whenever they opened its door
we'd rush in, grab one each and ride
round in circles like lunatics. But the
way I remember it, there were so many
of us we could never seem to keep going
for more than a couple of laps without
getting our wheels tangled up.

Breakfast Time

I painted the kids in this detention-centre scene wearing short trousers because I like painting socks and chubby little legs. In actual fact we all wore long trousers. The screws didn't wear uniforms in those places and tried to frighten you into going straight by shouting and using threatening behaviour.
Unfortunately it didn't work with me.

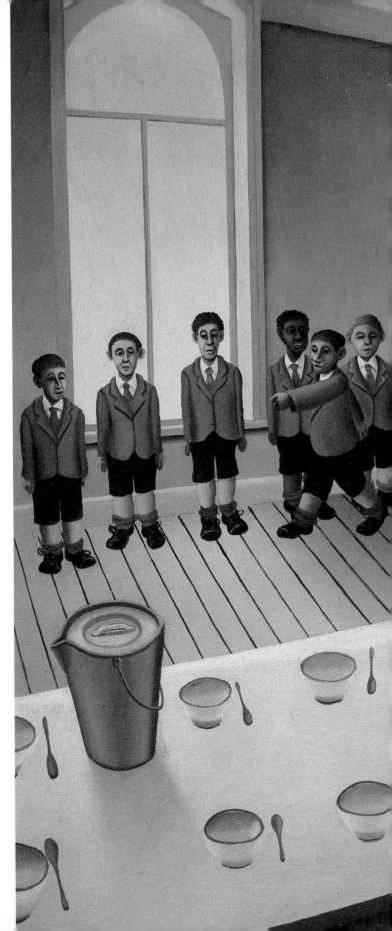

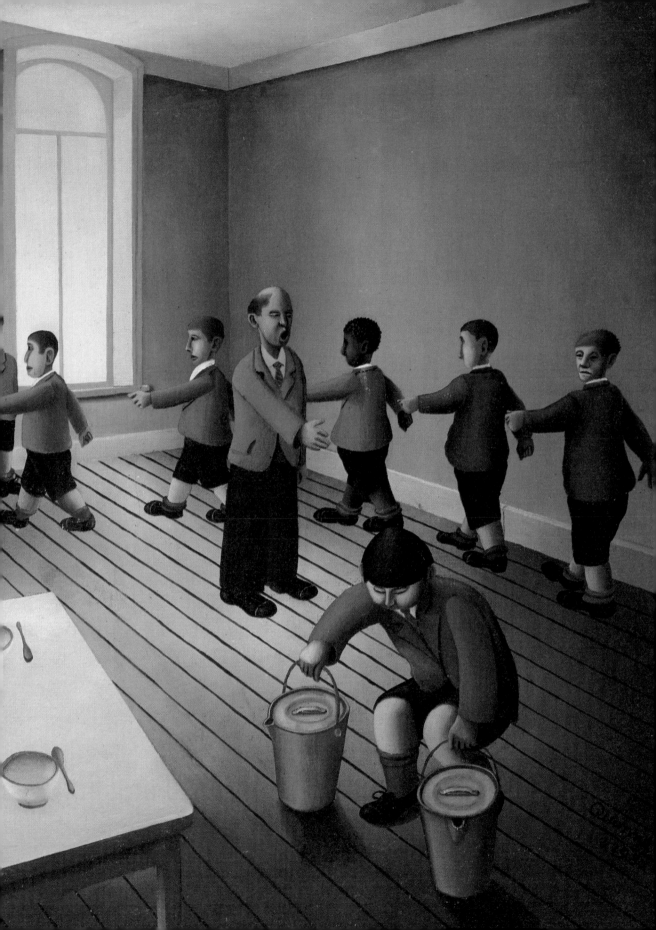

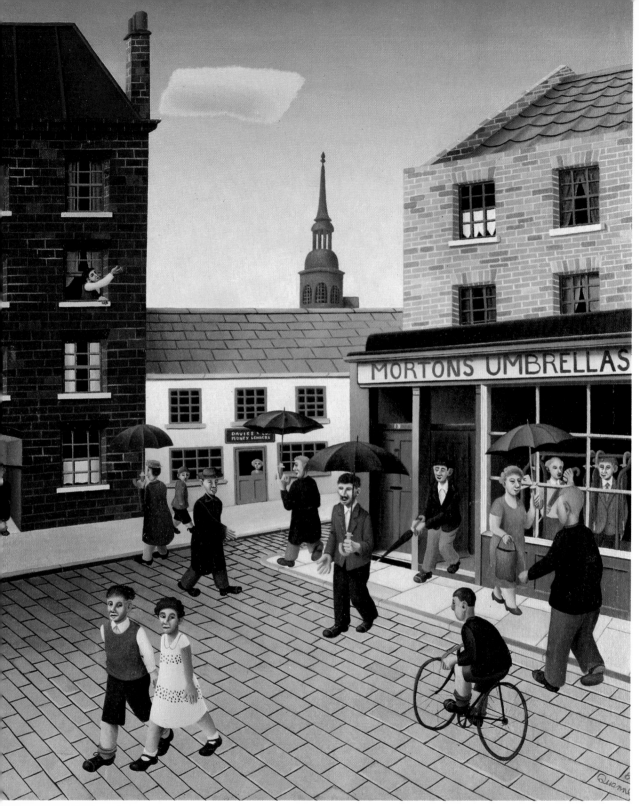

Umbrellas

This painting is about a very clever man who could sell umbrellas when it wasn't even raining.

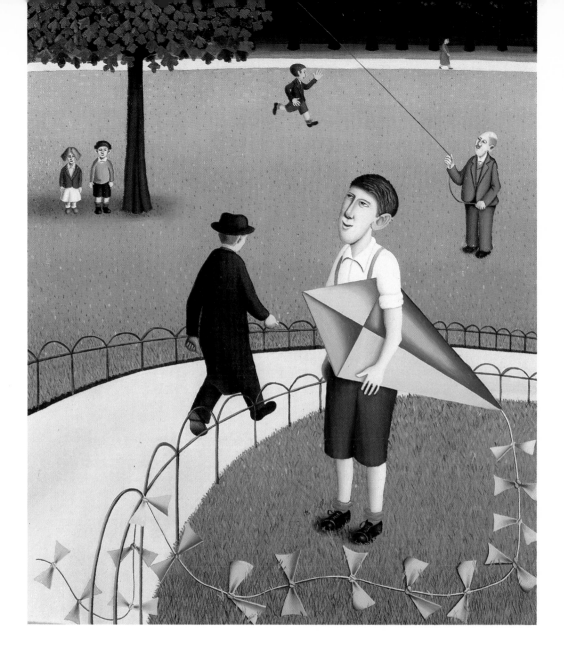

Kite Flyer

This is me with my kite over the Vicky Park in Bethnal Green. Sometimes I'd go there just to watch an old boy who went regularly and flew one so high that you had to strain your eyes to find it. I was always trying to make my own but never managed to get one to fly even as high as the tree tops. They generally just went up a few feet and came straight down like a ton of bricks. To this day I can't resist stopping to look whenever I see kite flyers.

The Rite of Spring

One evening I was sitting in my cell reading a newspaper. I had the radio on but I wasn't taking any notice of it. I like music but I can't take in anything else while I'm reading. However, a terrible sound actually forced me to stop reading and start listening. The only way I can describe it is like a train getting up steam. But it also had something sinister about it, as if you knew that the train couldn't be stopped and would keep going until it crashed into something. The picture I saw at the time was of a train flying along above a street with all these children down below chasing after it. I got a sheet of paper and did a quick sketch of what I had in my head. A bit later I heard the radio announcer say 'You have been listening to *The Rite of Spring* by Igor Stravinsky.'

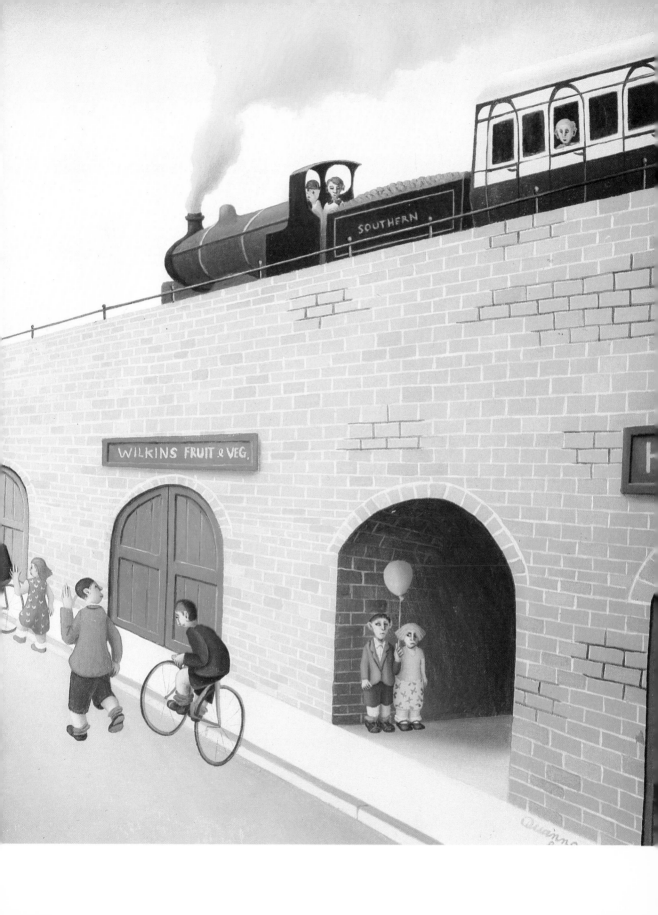

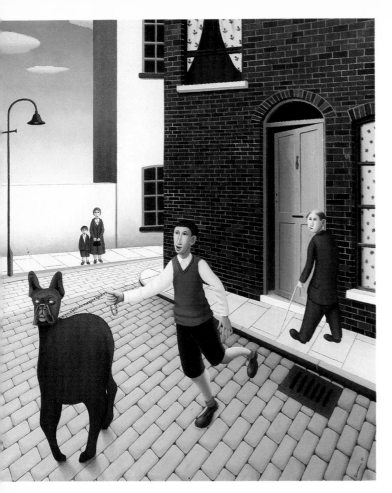

Approved School Boy

This man was doing nine years for blowing safes. When I met Bill he was on his way out, but without Parole. I asked him if he'd be going straight now, after all that bird. He told me he doubted it. He said bird didn't bother him anymore, they'd done everything they could to him as a kid. They'd sent him to an approved school where you had to go out digging up fields in the freezing cold. The man that ran the place was evil and used to go around whacking the kids with a big stick. I never went to approved school myself because I didn't start up in crime until I was sixteen. In this painting Bill is twelve years old. I actually painted his portrait from life and just stuck the result onto a young pair of shoulders.

Boy with Blind Dog

In one of my recent paintings I had trouble with the eyes of a dog I'd included, so I went out and found a real dog to check on. I then discovered that I'd gone wrong in giving my dog human eyes. I immediately went home and changed them but then realised that it looked blind. I left the painting as it was and strangely enough grew to like it more and more. So much so that I finally decided to do this one with another blind dog as the main theme.

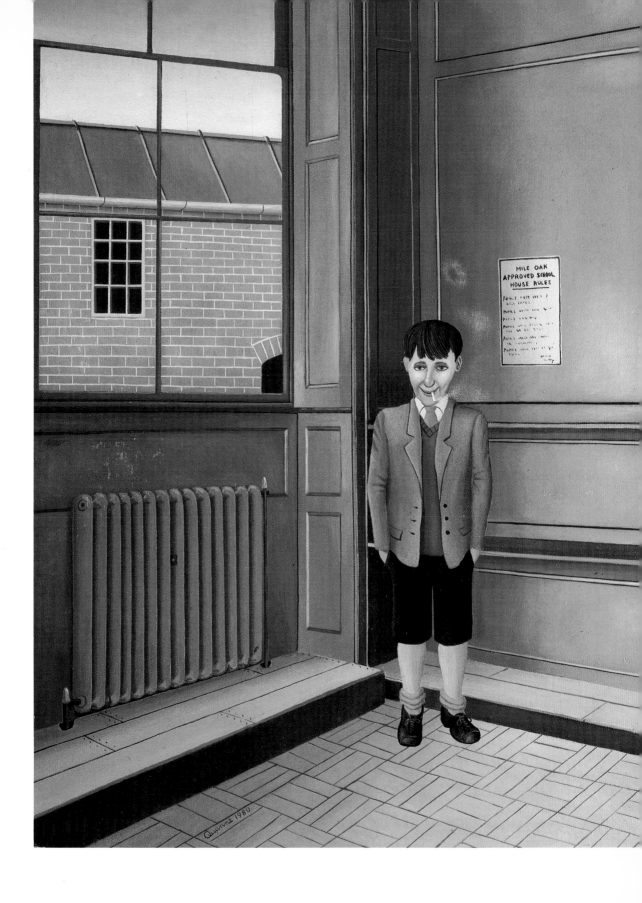

The Biggest Boy in the World

I've always had a very good memory for things that
happened when I was a kid. In this painting I'm at
the window of a café that my mother had taken me
into when she'd met the lady from next door out
shopping one day. I remember vividly seeing this
boy outside. He was going by on a bike that was too
small for him. He seemed to be getting along O.K.
but for some reason I started worrying about it. I
used to worry about almost everything when I was a
kid. I asked my mother at the time why this boy was
on a bike that was too small. She looked across
through the window and then she turned round and
said it wasn't the bike that was small it was the boy
who was big! So being eight years old the next thing
I wanted to know was if he was the biggest boy in
the world. The answer my mother gave me to that
question was, 'yes he's the biggest boy in the world
come away from the window Michael.'

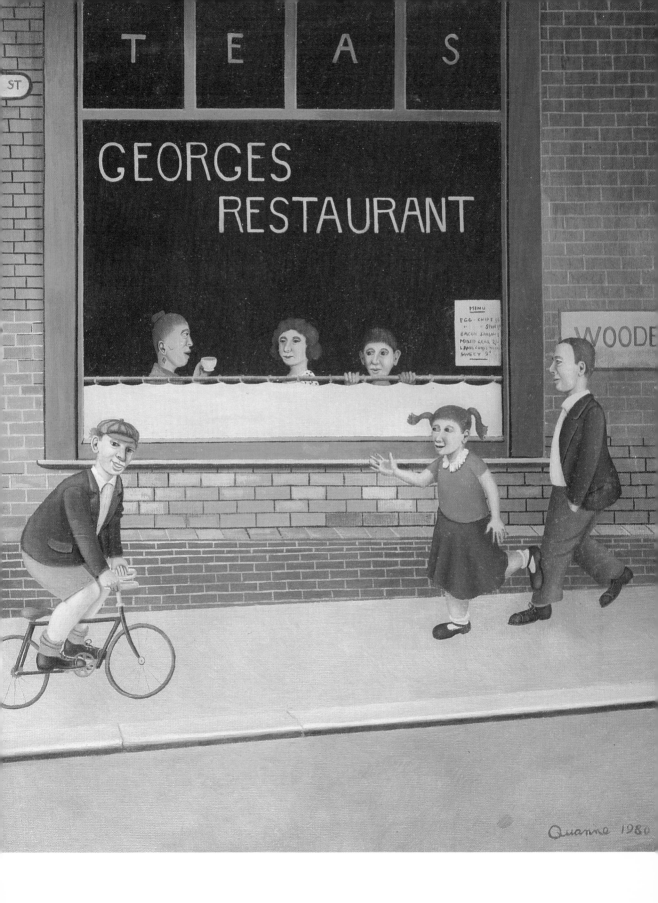

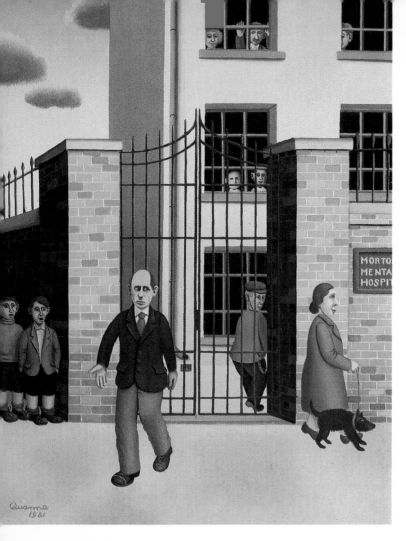

Matchstick Model Makers

These men are in a prison cell. Today even prison bars are made to resemble conventional window frames. Look at the faces. Can you detect malevolence? They are in one of those new high security establishments, with long sentences for violent crimes. The one holding the model is named The Axeman. What else is there to know? Have another look. It is really a painting of two eighteenth-century monks whose heads I modelled from an old print reproduced in a magazine. This is my personal protest against labels and shallow descriptions of character in general.

The Man

In 1953 I had a mate whose old man was in an asylum out in the sticks for a couple of years. One day we went to visit him. But when we arrived we were told that we wouldn't be allowed in without an adult and anyway visits had to be arranged beforehand. We hung about outside and while we were there a porter opened the gates to let out a very evil-looking man with staring eyes. Apparently the inmates who weren't considered dangerous were let out for walks once a week. But this one looked like a real lunatic. We followed him down the road to see if he'd do anything. He went into a café so we went in after him. Then he started talking to the bloke behind the counter about the asylum. According to what we overheard, the man we'd followed was as right as rain. He was only one of the hospital workers who'd just finished a shift.

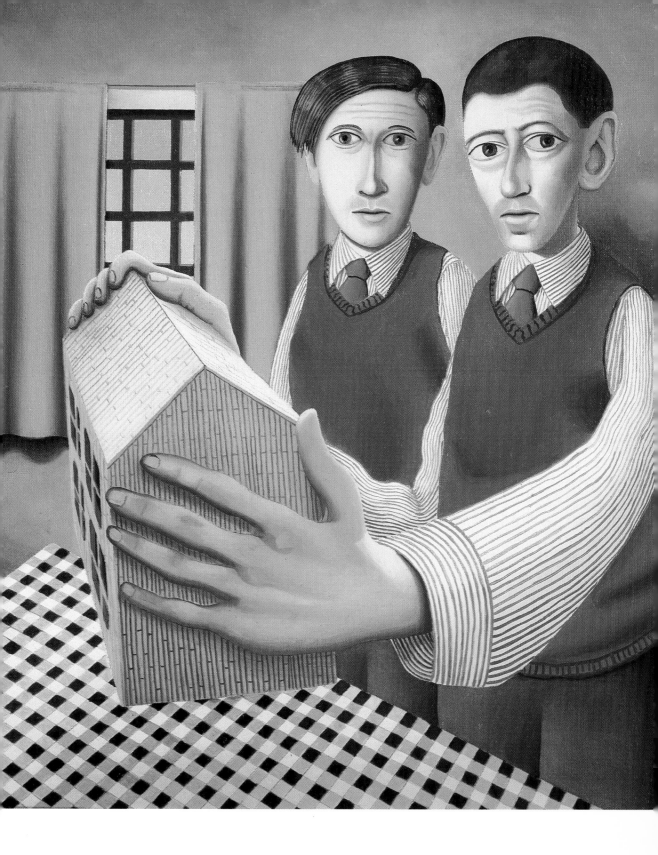

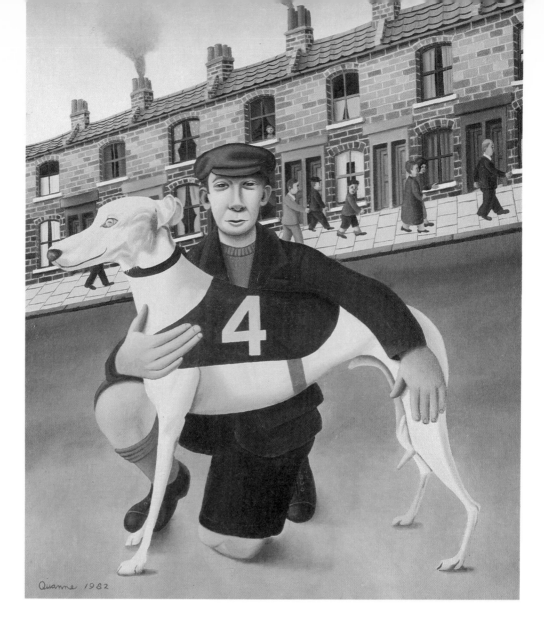

Tin Pot Teddy

One day in 1954 a mate of mine had to go to our local greyhound stadium with his old man who had a tip to back. I happened to be with him at the time so I went too. The tip was a dog called Tin Pot Teddy and it ended up winning by a distance so we all had pie and mash in a place near the track. I've been going greyhound racing ever since and Tin Pot became my favourite runner at the stadium, winning almost every time I backed him. Although he's been dead now for a long time I managed this painting from memory. In actual fact it's wishful thinking because the nearest I ever got to him was when I once leaned over some railings and patted him.